FROM THE FILMS OF

Harry Potter™

DELUXE PAPER DOLLS

ILLUSTRATED BY NATALIA SANABRIA

WIZARDING WORLD

INSIGHT EDITIONS

SAN RAFAEL · LOS ANGELES · LONDON

INSIGHT
EDITIONS

PO Box 3088
San Rafael, CA 94912
www.insighteditions.com

Find us on Facebook: www.facebook.com/InsightEditions
Follow us on Instagram: @insighteditions

Copyright © 2024 Warner Bros. Entertainment Inc.
WIZARDING WORLD characters, names and related indicia are © & ™ Warner Bros. Entertainment Inc. WBSHIELD: © & ™ WBEI. Publishing Rights © JKR. (s24)

All rights reserved. Published by Insight Editions, San Rafael, California, in 2024.

No part of this book may be reproduced in any form without written permission from the publisher.

ISBN: 979-8-88663-019-0

Publisher: Raoul Goff
SVP, Group Publisher: Vanessa Lopez
VP, Creative: Chrissy Kwasnik
VP, Manufacturing: Alix Nicholaeff
Art Director: Stuart Smith
Editorial Director: Paul Ruditis
Editorial Assistant: Jennifer Pellman
VP, Senior Executive Project Editor: Vicki Jaeger
Senior Production Manager: Greg Steffen
Senior Production Manager, Subsidiary Rights: Lina s Palma-Temena

Illustrations by Natalia Sanabria

ROOTS of PEACE REPLANTED PAPER

Insight Editions, in association with Roots of Peace, will plant two trees for each tree used in the manufacturing of this book. Roots of Peace is an internationally renowned humanitarian organization dedicated to eradicating land mines worldwide and converting war-torn lands into productive farms and wildlife habitats. Roots of Peace will plant two million fruit and nut trees in Afghanistan and provide farmers there with the skills and support necessary for sustainable land use.

Manufactured in China by Insight Editions

10 9 8 7 6 5 4 3 2 1

INTRODUCTION

TEN YEARS. EIGHT FILMS. THREE OF THE MOST MEMORABLE, MAGICAL CHARACTERS.

Harry Potter. Ron Weasley. Hermione Granger.

From their arrival as first-year students at Hogwarts School of Witchcraft and Wizardry in *Harry Potter and the Sorcerer's Stone* to their final battle against Lord Voldemort in *Harry Potter and the Deathly Hallows – Part 2*, the trio has grown up before the eyes of fans worldwide, exploring their magical abilities and learning the true meaning of courage and friendship as part of their journey.

This book includes beautifully rendered paper dolls of the core trio alongside fan-favorite characters Luna Lovegood, Draco Malfoy, Neville Longbottom, Professor Albus Dumbledore, and Bellatrix Lestrange. You'll also find some of their most recognized costumes from the film series.

Along the way, you'll encounter fascinating information about how the costume designers helped to define the characters' looks through their wardrobe choices, behind-the-scenes trivia, and interviews with the Harry Potter cast.

INSTRUCTIONS

To display the dolls, carefully punch out the stand that accompanies each character. Fold each stand along the fold lines so the stand forms a triangle and then attach the two end flaps. Glue the back of the paper doll's feet to the front of the stand.

For the background scenes, carefully cut out each scene from the front and back covers. Insert the bottom of each scene into the display stands provided in the final two pages of the book. The cover can also be removed from the book to create a background pattern.

HARRY POTTER

"You're a wizard, Harry!"

RUBEUS HAGRID
Harry Potter and the Sorcerer's Stone

When actor Daniel Radcliffe, who played Harry Potter, prepared to shoot the first film in the series, Harry Potter and the Sorcerer's Stone, he said, "I had no idea what I was getting into." The actor went on to portray "the boy who lived" in eight films, evolving from a first-year student at Hogwarts School of Witchcraft and Wizardry to become a capable wizard who must face the threat of Lord Voldemort.

At Hogwarts, students are sorted into one of four houses: Gryffindor, Hufflepuff, Ravenclaw, and Slytherin. Harry and his best friends, Hermione Granger and Ron Weasley, are sorted into Gryffindor, whose house colors are red and gold. To capture the unique look of each house, Harry Potter and the Sorcerer's Stone costume designer Judianna Makovsky turned first to the books as source material. However, she said, "Funnily enough . . . the kids did not wear uniforms!" The filmmakers ended up testing Radcliffe wearing wizard robes with street clothes and then wearing a school uniform. "Everybody went for the uniforms," Makovsky explained, "because graphically it was much prettier."

Over the course of the series, the characters were increasingly filmed out of their school uniforms. According to *Harry Potter and the Prisoner of Azkaban* costume designer Jany Temime, "It's so important [for kids that age] to be cool, and you start being an individual yourself, wanting to have your own clothes, your own look, and that's why we had to be more individualistic and to give them new cool clothes." The challenge ultimately was to dress the Hogwarts students in clothes that felt modern yet also reflected the culture of magic that surrounded them.

> "Have you heard? Harry Potter's the new Gryffindor Seeker. I always knew he'd do well."
>
> NEARLY HEADLESS NICK
> *Harry Potter and the Sorcerer's Stone*

HERMIONE GRANGER

"Actually, I'm highly logical which allows me to look past extraneous detail and perceive clearly that which others overlook."

HERMIONE GRANGER
Harry Potter and the Deathly Hallows – Part 1

Nine-year-old Emma Watson was in the middle of reading the third Harry Potter book, *Harry Potter and the Prisoner of Azkaban*, when she auditioned for the part of bright, brilliant Hermione Granger. "This rumor started getting around my school that there were these auditions for Harry Potter and they were coming to school," the actress explained. She auditioned, "and I got a call three weeks later, and the rest is history!" Soon she joined fellow cast members Daniel Radcliffe and Rupert Grint on set, forming the core trio of Harry, Ron, and Hermione.

Initially, costume designer Judianna Makovsky had a very definite idea of how to bring the character of supersmart Hermione Granger to the screen. "I tried to keep Emma really classically British," she said. "We found pleated skirts, knee socks, lovely hand-made Fair Isle sweaters, looking back to the 1930s and 1940s British boarding schools." In particular, Makovsky said that the wardrobe department did a lot of research into the World War II era as they tried to make all the costuming choices for the Hogwarts students fit a quintessentially British tone.

According to costume designer Jany Temime, as the film series progressed, the actress had a definite idea of what Hermione would wear, and that played a role in her wardrobe decisions. "Emma is a beautiful young girl, and she has fashion sense and knows what's good for the part and what's good for her," Temime said. "She understands that we have to dress her as Hermione, and not as Emma. [She would say,] 'Hermione will wear that . . . of course, it's not *my* taste, but Hermione will wear that.'"

"Just because you've got the emotional range of a teaspoon . . ."

HERMIONE GRANGER TO RON WEASLEY
Harry Potter and the Order of the Phoenix

While filming the Yule Ball scenes for *Harry Potter and the Goblet of Fire*, Emma Watson was "absolutely terrified I was going to rip [the dress] or spill something on it. So, literally, I would not sit in it. I would not walk in it. I would not do anything in it, apart from what I had to do in it, because I was so worried I was going to wreck it!"

RON WEASLEY

"You're a little scary sometimes, you know that? Brilliant, but scary."

RON TO HERMIONE
Harry Potter and the Sorcerer's Stone

Right from the start, actor Rupert Grint felt a kinship with his character, Ron Weasley. "I always felt quite a connection," he said. "Obviously, we've both got quite large families, a lot of brothers and sisters and stuff. I always thought my family were quite similar to the Weasleys, really." Bolstered by that feeling of connection, Grint sent in an audition tape, where he rapped about himself. "It was quite funny," Grint mused. It must have been quite a good rap, because he got the part!

Costume designer Judianna Makovsky took a somewhat unorthodox approach in creating Ron Weasley's look. "Rupert's character was a little different [than the others] because his mother likes to hand-make all the sweaters and clothes," Makovsky said. "And so we had a lot of sweaters knit that looked a little off, that weren't perfect. Because his family are a little bit of outcasts, we tried to make his clothes just a little stranger than everybody else's." Perhaps the best example of Ron's "different" style appears in *Harry Potter and the Goblet of Fire*, when Ron's mother sends him dress robes to attend the Yule Ball. The robes are extremely old-fashioned, prompting Ron to say, "I look like my Great Aunt Tessie!"

One of the challenges in creating Ron Weasley's wardrobe over the course of the films was to show the character's maturity while staying true to his core character. Costume designer Jany Temime described Ron's style as "a mix of clumsiness and awkwardness, but somehow, it was also sort of fashionable to be that cool in being that wrong. It works for him, and a lot of people think that he's the best dressed of the three [Ron, Harry, and Hermione]!"

Starting with *Harry Potter and the Prisoner of Azkaban*, Rupert Grint was encouraged by director Alfonso Cuarón and costume designer Jany Temime to find his own unique look. "[Cuarón] said that you should customize how you would look if you were really at school, so it feels more natural . . . Untucked shirt and loose tie!"

"Why is it, when something happens, it is always you three?"
"Believe me, Professor, I've been asking myself the same question for six years."

PROFESSOR MINERVA MCGONAGALL AND RON WEASLEY
Harry Potter and the Half-Blood Prince

DRACO MALFOY

"Think my name's funny, do you? No need to ask yours. Red hair . . . and a hand-me-down robe. You must be a Weasley."

DRACO MALFOY TO RON WEASLEY
Harry Potter and the Sorcerer's Stone

"Scarily, I've been involved with Harry Potter since I was eleven," actor Tom Felton said. Over the course of eight films, Felton served as the perfect foil to the kindhearted Harry Potter: the devious Draco Malfoy. Recalling how he was cast in the part, Felton said, "We were all so young that it's very difficult to have an acting ability at that age." But he felt that Chris Columbus, who directed the first film, *Harry Potter and the Sorcerer's Stone*, was looking for "character. How you are as a person. Whether they can see you growing into the character they want." Felton was enormously grateful to Columbus for seeing his inner Malfoy.

"Training for the ballet, Potter?"

DRACO MALFOY TO HARRY POTTER DURING A QUIDDITCH MATCH
Harry Potter and the Chamber of Secrets

In selecting the look for the Slytherin Draco Malfoy, costume designer Judianna Makovsky opted for a stripped-down look. "We tried to keep it very simple and very dark. Because at that point [in the first movie], Draco was a little bit evil-minded. I thought we said it more with his [slicked-back] hair and kept the clothes simple. Often the way I design, I like to let the actor shine, and the clothes should not take over." Dressed in his school uniform for the first film, Draco certainly made an indelible impression as an antagonist and future threat.

As the character evolved over the series, costume designer Jany Temime helped bring out a vaguely sinister, elegant quality in Draco. "Tom is such an elegant, very sophisticated boy. It was hard to create something which will be traditional and wizardy, and still cool for young people. But I think we did." By the time we see him in the final two films of the series, *Harry Potter and the Deathly Hallows – Part 1* and *Part 2*, Draco dresses in all black, a sign of his outward allegiance to Lord Voldemort.

According to Tom Felton, the Quidditch scenes were particularly uncomfortable to film, especially in *Harry Potter and the Chamber of Secrets*. "It was on like a seesaw," Felton recalled. "We had one guy at one end with a lot of weights, and then you at the other end on a bicycle seat with a broom on it . . . there was a harness underneath and they tied you to the bicycle seat!"

LUNA LOVEGOOD

"I was bitten by a garden gnome only moments ago."
"Gnome saliva is enormously beneficial!"

LUNA LOVEGOOD AND HER FATHER, XENOPHILIUS LOVEGOOD
Harry Potter and the Deathly Hallows – Part 1

Actress Evanna Lynch earned the role of the unusual Ravenclaw student Luna Lovegood by attending an open audition in London, England. "It was 8 a.m. on a Saturday in January. It was packed! Loads of people, just thousands of people lining up. I had to read the scenes from the film. And after that, I had a screen test, and that was it, really!" Lynch, whose character was introduced in *Harry Potter and the Order of the Phoenix*, was a little intimidated as a newcomer to Hogwarts. "It was really daunting, you know? It was scary. It wasn't just that I was a new actor coming along. I was a fan!"

When it came time to choose the wardrobe for the eclectic Luna, costume designer Jany Temime was only too happy to get input directly from Evanna Lynch. "She knew the part better than me," Temime said. "Evanna insisted I start making earrings for her that were orange radishes. She was very specific about a few things which were from her character." Among the specific design elements that Lynch requested were strawberries. "We gave her shoes with strawberries," Temime elaborated. "We put the strawberries everywhere! I think she looks really cute, and she's perfect for the part."

"My mum always said things we lose have a way of coming back to us in the end. If not always in the way we expect."

LUNA LOVEGOOD
Harry Potter and the Order of the Phoenix

The character of Luna went on to appear in three more films (*Harry Potter and the Half-Blood Prince* and *Harry Potter and the Deathly Hallows – Part 1* and *Part 2*). As Luna grew up, Temime was careful to match the character's style with that of the actress. "Evanna's a very arty, crafty sort of girl, and she has the right personality [for Luna]. She's so happy to wear clothes in a different way. She doesn't try to be different."

Nearly every item worn by Evanna Lynch in her portrayal of Luna Lovegood had to be custom made. According to costume designer Jany Temime, "Everything has been made for her, besides the shoes. We bought the shoes. But everything else is really all made!"

NEVILLE LONGBOTTOM

"[I]t takes a great deal of courage to stand up to your enemies, but a great deal more to stand up to your friends."

PROFESSOR ALBUS DUMBLEDORE TO NEVILLE LONGBOTTOM
Harry Potter and the Sorcerer's Stone

Matthew Lewis had been acting since the age of five and had been a fan of Harry Potter from the moment he read the first book. "I asked my mom if there was a film made, could I audition for it. And then it came up, my agent heard about it. Just to be at the audition was spellbinding!" Cast in the role of Neville Longbottom, a brave Gryffindor student who was instrumental in defeating Lord Voldemort during the Second Wizarding War, Lewis was excited just to be a part of this magical world. "The idea of playing a character was not really on my mind. I just wanted to be in it, to be involved in the story in some way! I wanted to dress up like a wizard and go to Hogwarts. . . . [I] was just a little boy wanting to be in Harry Potter."

While interpreting the role of Neville across eight films, Lewis said the wardrobe played an important part in helping him get in character. "When you're an actor, it does help put you into the role. When you look in the mirror and you don't see yourself, you see the character, it really does help you focus a lot more."

Lewis kept his focus and worked hard to bring Neville Longbottom to life. "I was quite lucky with Neville," he explained. "He evolved so much over the years that every time I came back to the role, it was like playing somebody else. I've always tried to keep it fresh—instead of focusing on how Neville's the same, I focus on how he's different." Growing from the forgetful, awkward young boy in *Harry Potter and the Sorcerer's Stone* to become the fiercely loyal, defiant young man who stares down death itself to save his friends, Lewis made Neville Longbottom an unforgettable character.

"Harry's heart beat for us.
For all of us! It's not over!"

NEVILLE LONGBOTTOM AT THE BATTLE OF HOGWARTS
Harry Potter and the Deathly Hallows – Part 2

When asked about his favorite moment in the Harry Potter film series, Matthew Lewis immediately chose a scene that he was not in! "I really liked the scene in *Harry Potter and the Goblet of Fire* . . . the maze sequence. It was very, very eerie. It really had me on the edge of my seat!"

BELLATRIX LESTRANGE

"Well, well, well, look what we have here. It's Harry Potter. He's all bright and shiny, and new again, just in time for the Dark Lord."

BELLATRIX LESTRANGE
Harry Potter and the Deathly Hallows – Part 1

Playing the role of Bellatrix Lestrange, a Death Eater and an ardent supporter of Lord Voldemort, in 2007's *Harry Potter and the Order of the Phoenix*, actress Helena Bonham Carter described her character as "sort of without limits." In Bellatrix's mind, there's no doubt that Lord Voldemort will destroy Harry Potter. "She's such a fanatic," Bonham Carter said. "She's pretty convinced by [Voldemort's] supremacy and his superiority and worthiness. I mean, she just loves him!" It's this unhinged, undying devotion to He Who Must Not Be Named that made Bellatrix such a force of evil.

When asked what she would miss after appearing in the Harry Potter films, Bonham Carter was quick to say, "I loved working with [costume designer] Jany Temime. It was a real collaboration." In particular, there was a moment in *Harry Potter and the Deathly Hallows – Part 2* when Hermione used a Polyjuice Potion to impersonate Bellatrix. "That was a challenge," Temime said, "because the costume had to be worn by both Emma [Watson, who plays Hermione] and Helena. It's very difficult to create the same costume worn by a teenager and a full-grown woman, because of the shape." The costume designer had to consult with both actresses, who then had to closely study each other's moves to determine how they would move in the dress.

> "Good morning!"
> "'Good morning'? 'Good morning'? You're Bellatrix Lestrange, not some dewey-eyed school girl."
>
> HERMIONE GRANGER, DISGUISED AS BELLATRIX LESTRANGE, AND GRIPHOOK
> *Harry Potter and the Deathly Hallows – Part 2*

Of her performance as Bellatrix Lestrange, Bonham Carter said, "It's been fun. It's very therapeutic, I must say, 'cause one day [during the filming of *Harry Potter and the Half-Blood Prince*], I just had to run down to Hogwarts, to a table in the Great Hall, and just kick everything off it. [Bellatrix] is a real anarchist . . . lots of cackling and running around!"

ALBUS DUMBLEDORE

"A child's voice, however honest and true, is meaningless to those who've forgotten to listen."

ALBUS DUMBLEDORE
Harry Potter and the Prisoner of Azkaban

When asked if he had any idea when he signed on to play Albus Dumbledore in *Harry Potter and the Prisoner of Azkaban* that he'd be playing the part years later, actor Michael Gambon replied, "Well, I knew it was an ongoing character. I thought, 'Well, it's seven novels, so I've got seven appearances.' But I didn't realize it would be over such a long period of time! And I've loved it. I made lots of friends. It's like a family." Gambon took over the role from actor Richard Harris, who portrayed Dumbledore in the first two Harry Potter films. As the Hogwarts Headmaster, Gambon brought a sense of authority with a twinkle of mischief to the halls of the magical school.

To bring Albus Dumbledore to life, costume designer Judianna Makovsky started with the books as source material. "Dumbledore is in purple," Makovsky said, but she probed deeper to get the details right. "He was a clotheshorse and had a sense of humor." Ultimately, she found inspiration in a Renaissance painting to set the headmaster's clothes apart from the rest of the staff's, describing his style as "glamorous." And to make her point about Dumbledore loving fashion, Makovsky stated that Dumbledore "changes clothes more than anybody" in *Harry Potter and the Sorcerer's Stone*!

> Costume designer Judianna Makovsky deliberately looked to different time periods for inspiration when choosing each teacher's wardrobe. For Dumbledore, Makovsky settled on nineteenth-century England, particularly the works of author Charles Dickens. "That was a period that Dumbledore liked, and he enjoyed the robes, and so he kept that look," Makovsky explained.

When asked to elaborate on what Michael Gambon brought to the role of Harry's mentor and how she tried to evoke that with her wardrobe choices, costume designer Jany Temime said, "He never took it very seriously. Michael always played Dumbledore with a twist. Dumbledore was somebody who had so much talent, so much intelligence, that we showed it with his clothes. And that gave us a Dumbledore full of light, full of spirit, and full of stories." It's this twist and sparkle that Gambon brought to the part and that audiences will always remember.

> "Once again, I must ask too much of you, Harry."
>
> ALBUS DUMBLEDORE
> *Harry Potter and the Half-Blood Prince*

Scene stands

Scene stands